ON READING

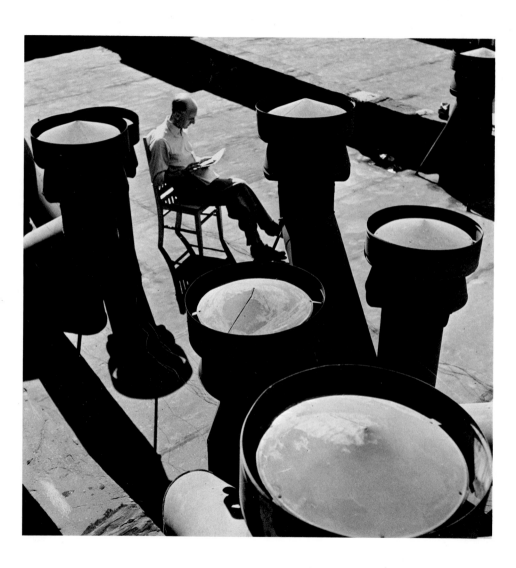

ON
READING

André KERTÉSZ

GROSSMAN PUBLISHERS
NEW YORK
1971

To my brothers

Copyright © 1971 by André Kertész.
All rights reserved.
First published in 1971 by Grossman Publishers
44 West 56 Street, New York, N.Y. 10019.
Published simultaneously in Canada by
Fitzhenry and Whiteside, Ltd.
SBN: 670-52459-X
Library of Congress Catalogue Number: 76-155564
Printed in the U.S.A. by
Rapoport Printing Corp. in the Stonetone Process.
Designed by Jacqueline Schuman

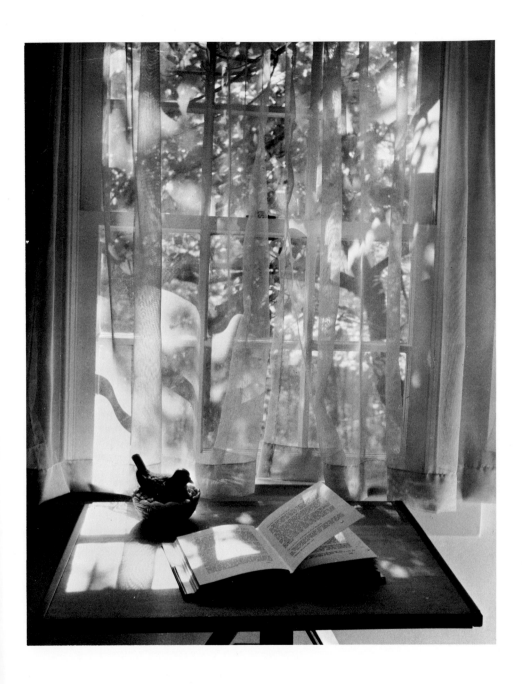

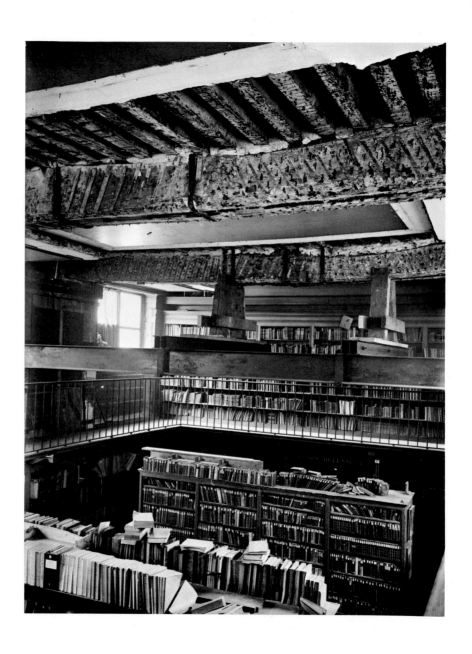

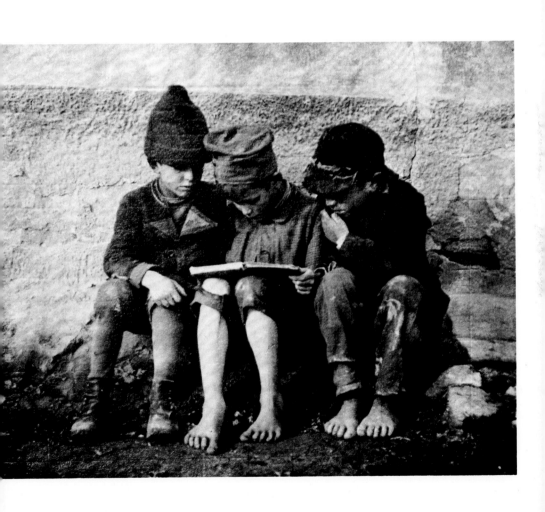

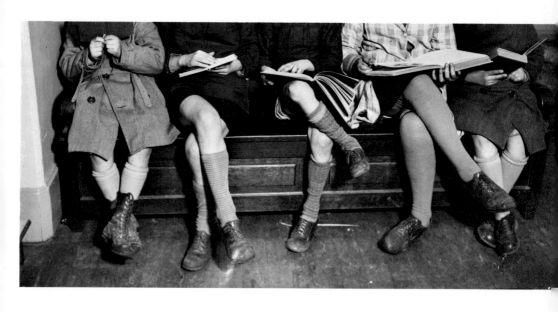

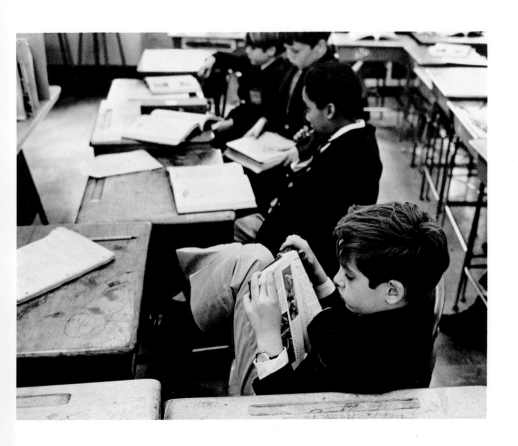

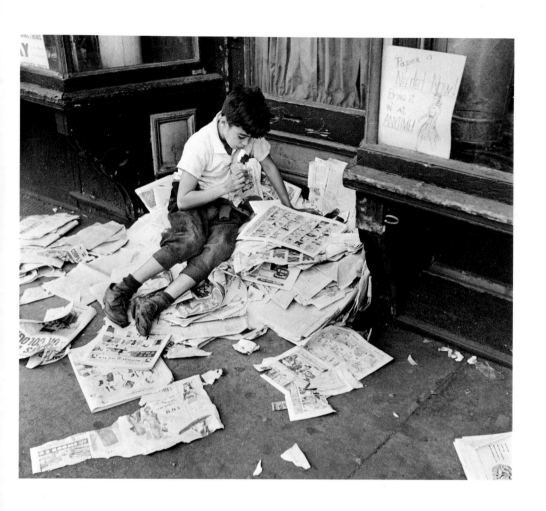

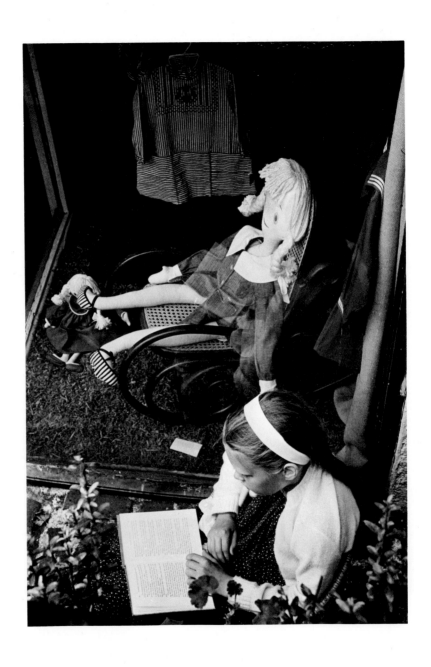

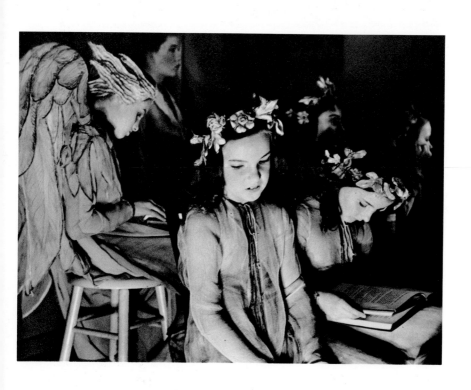

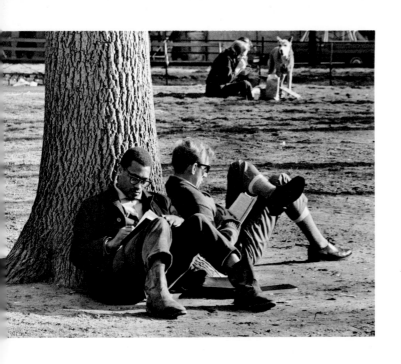

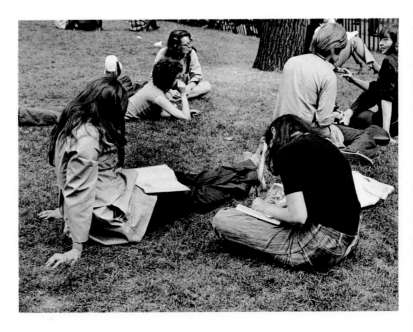

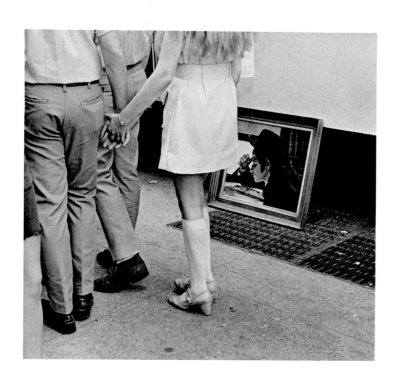

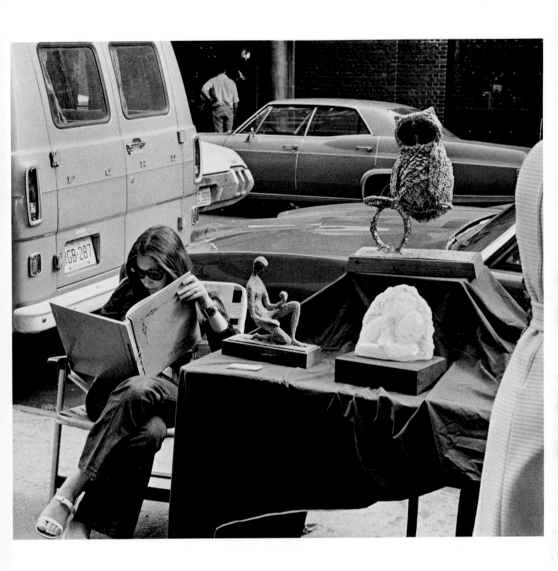

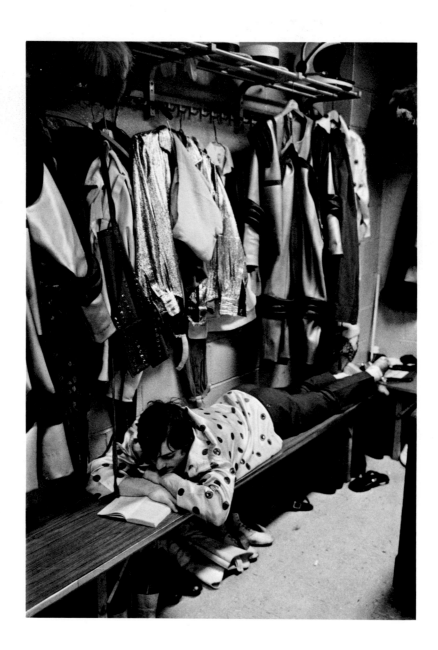

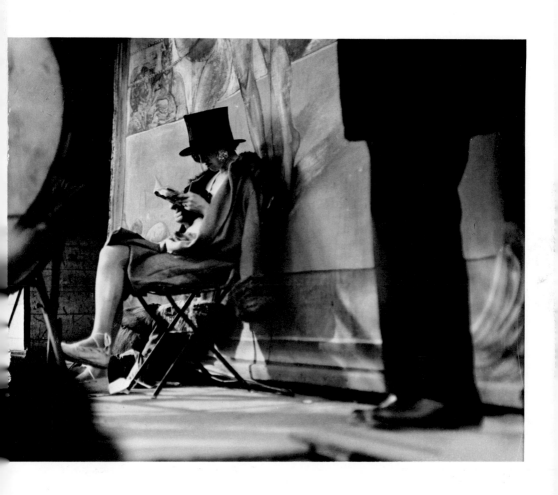

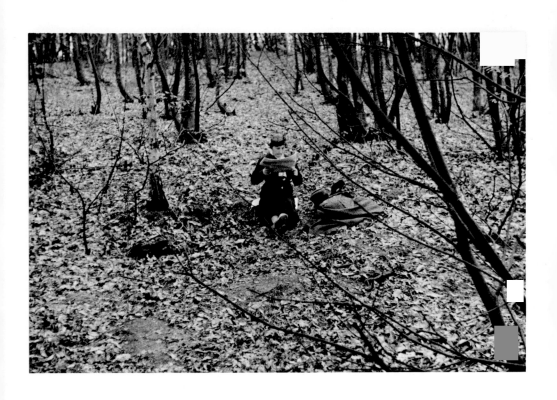

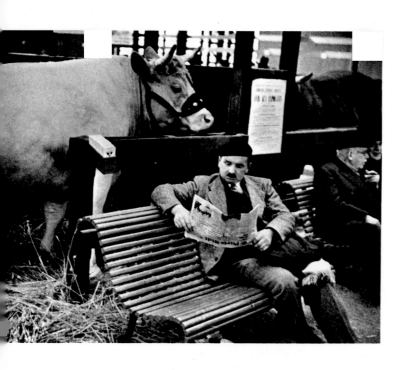

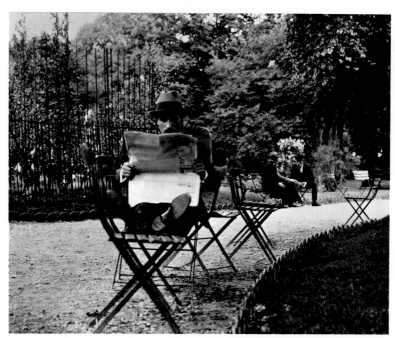

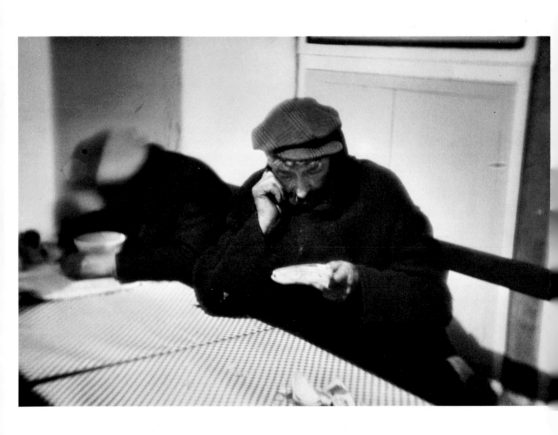

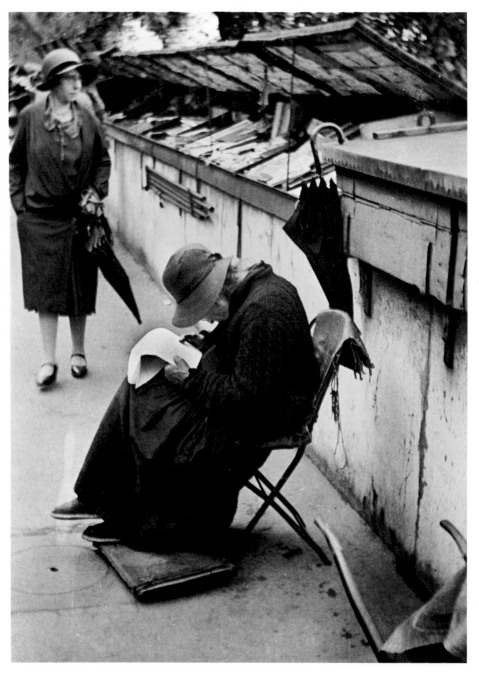

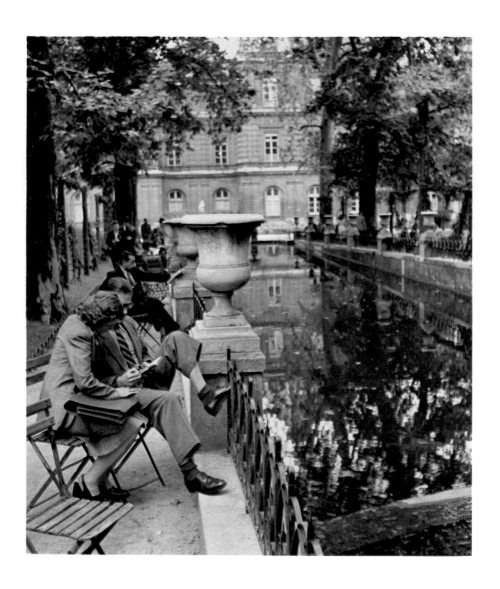

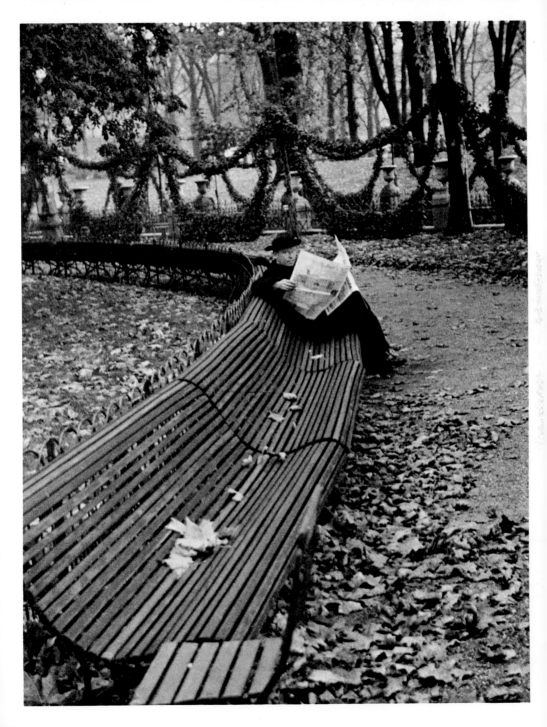

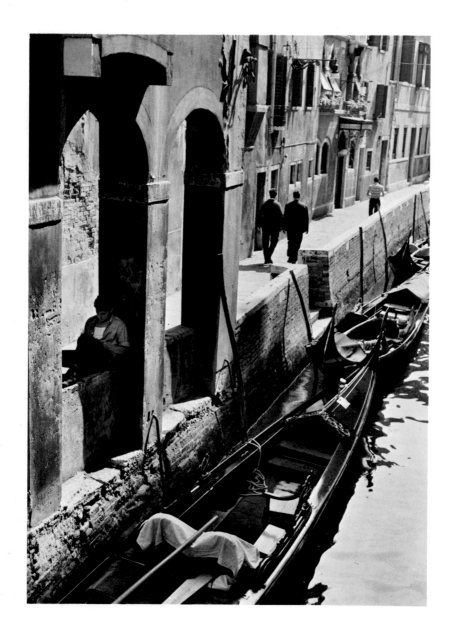

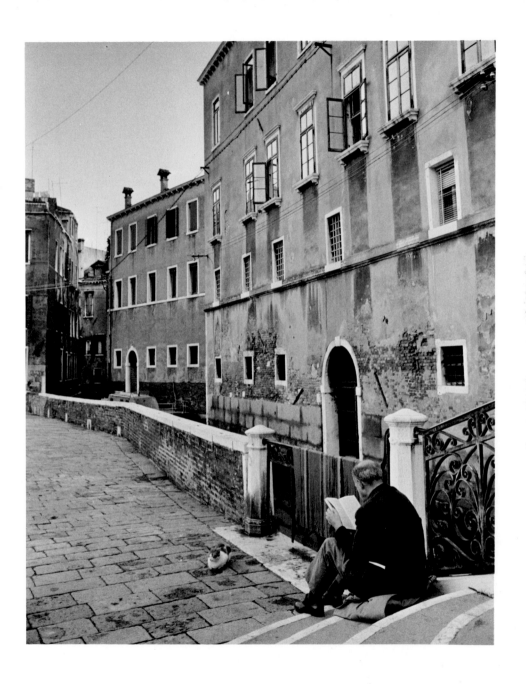

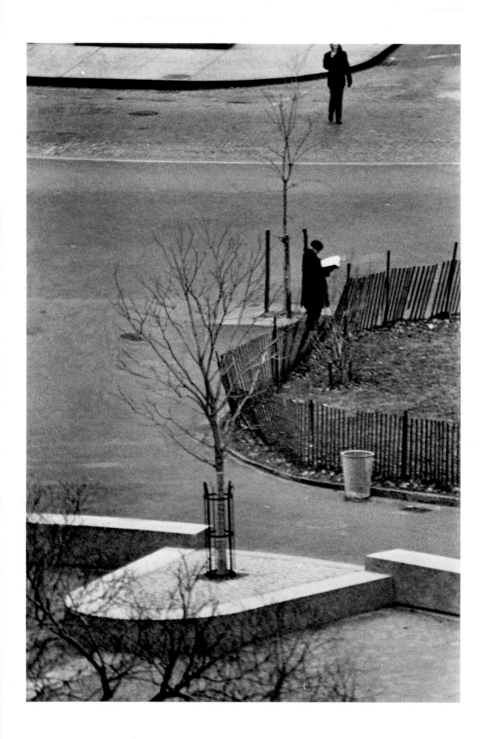

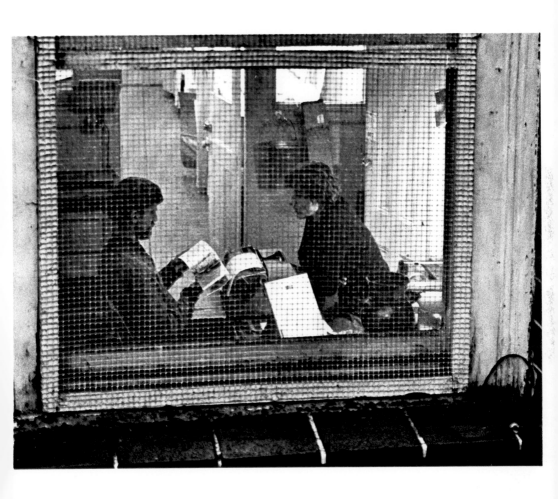

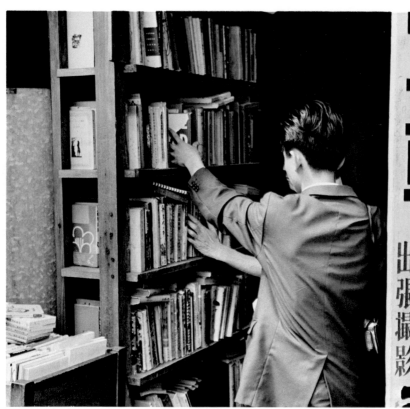

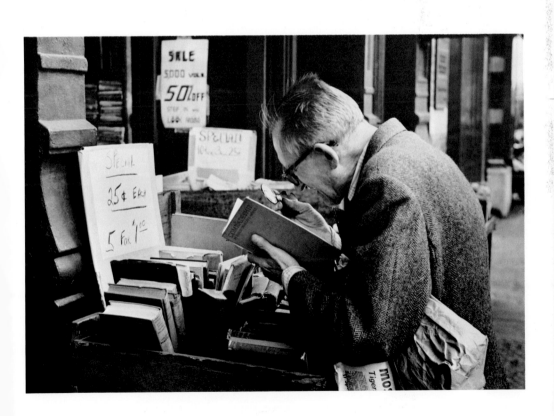

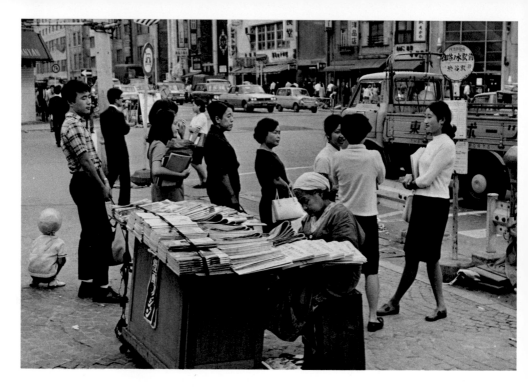

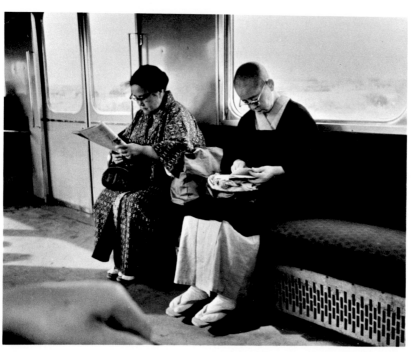

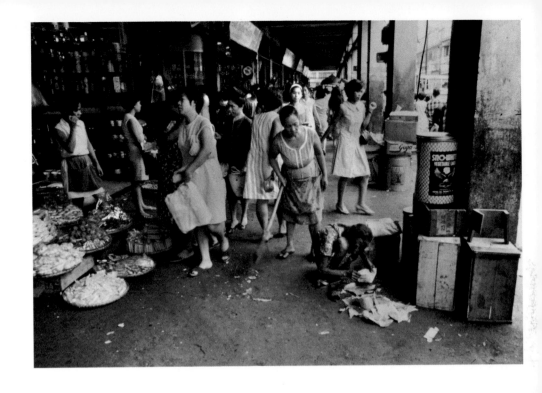

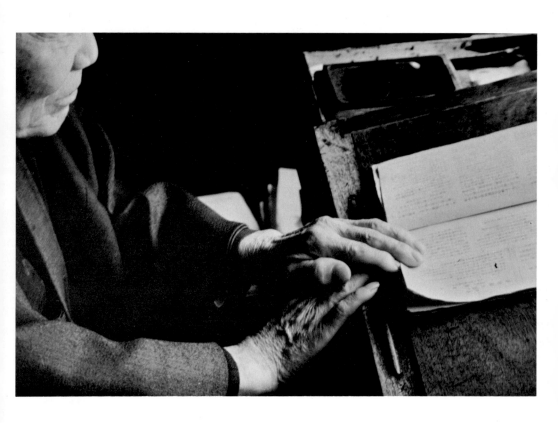

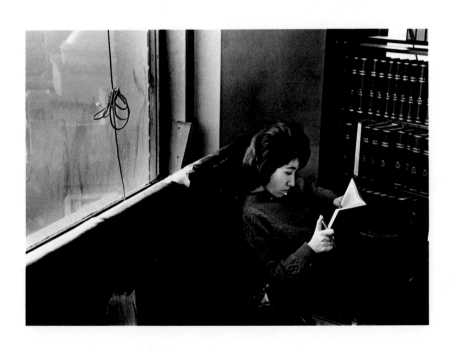

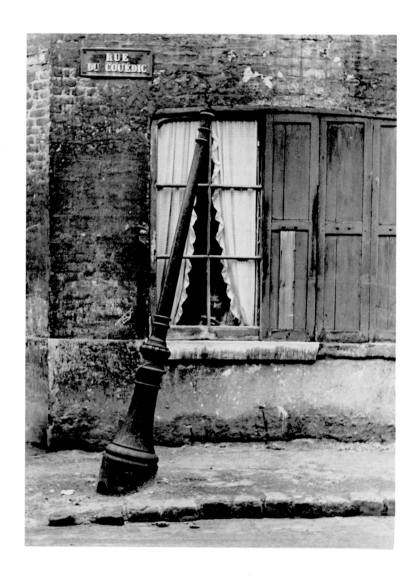

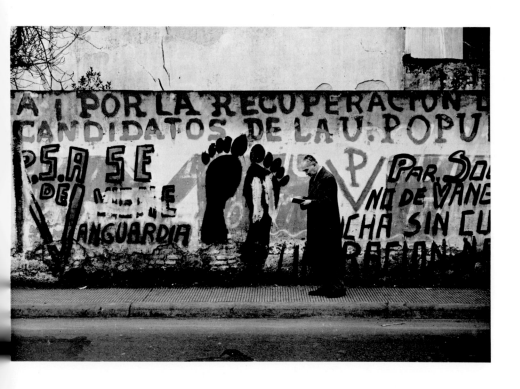

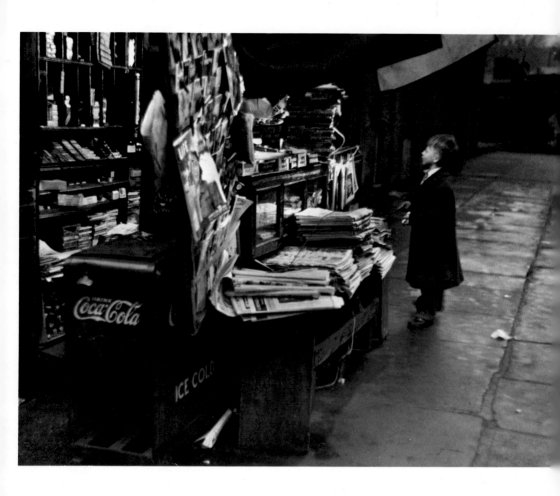

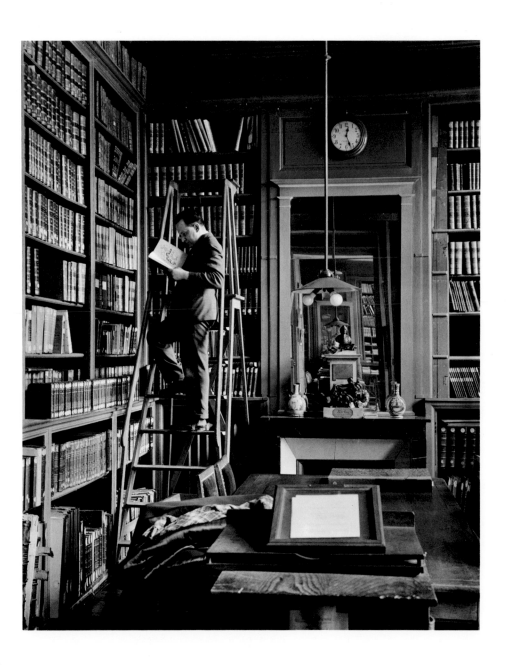

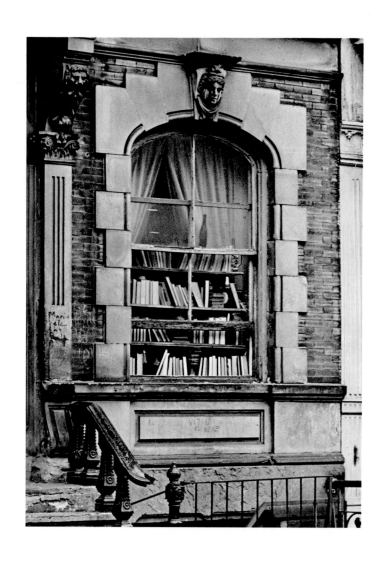

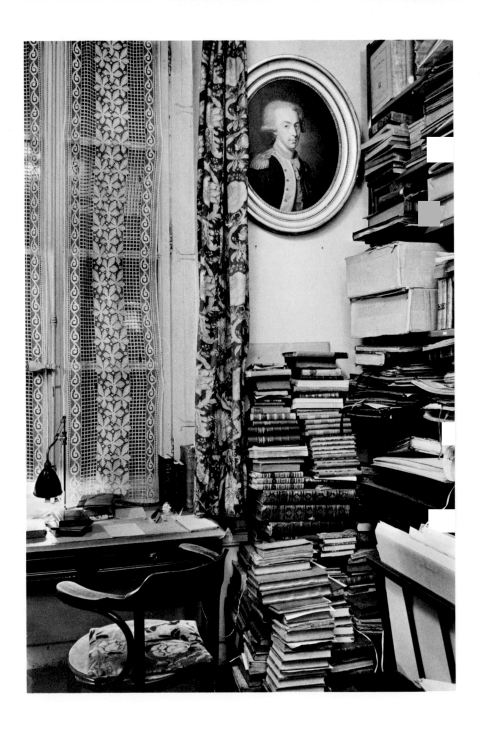

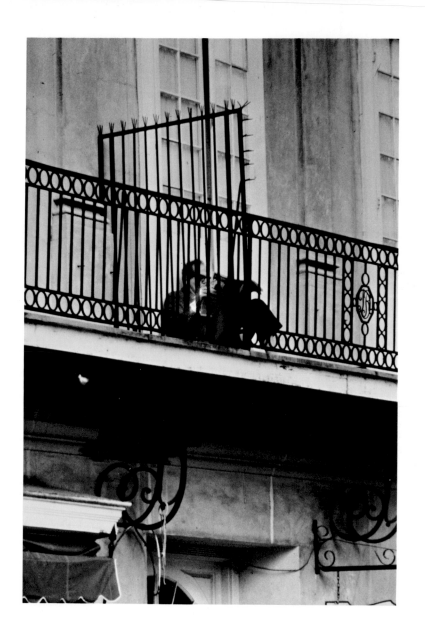

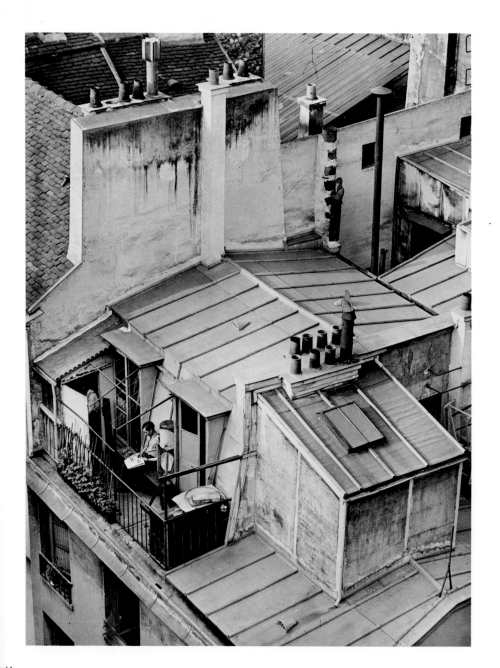

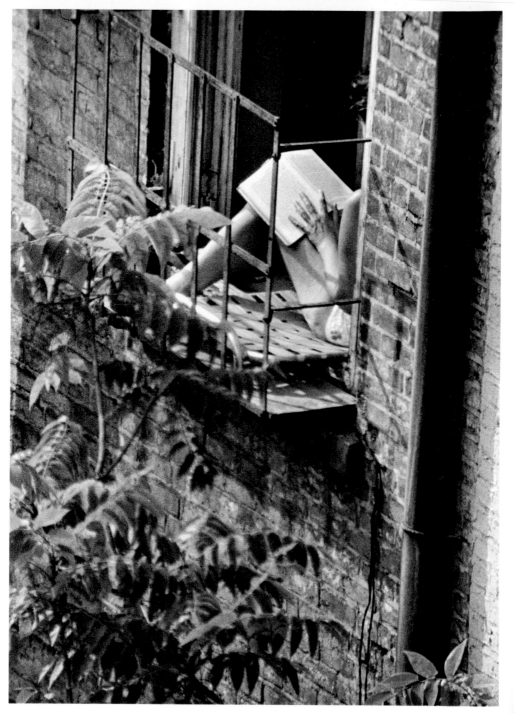

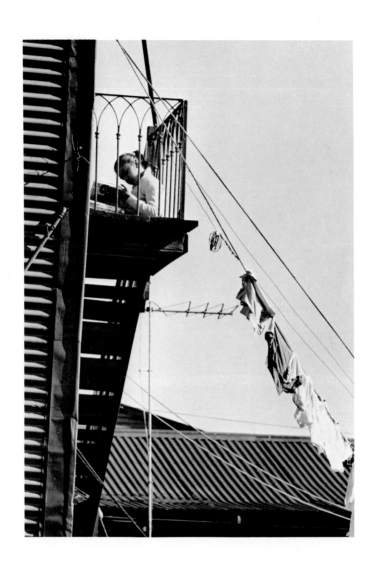

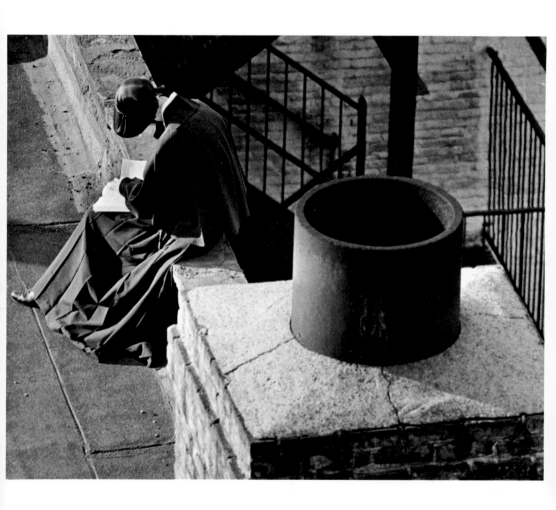

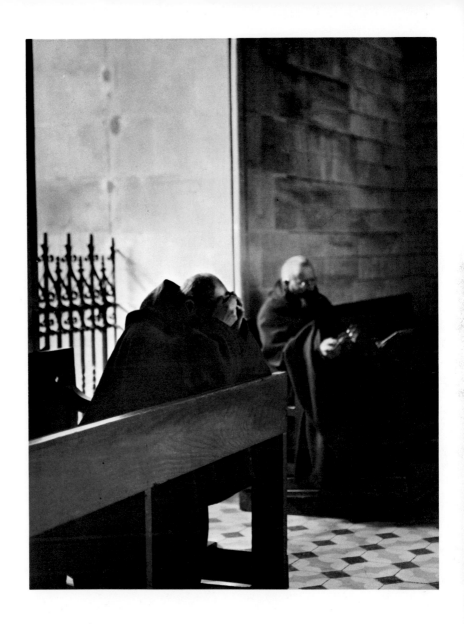

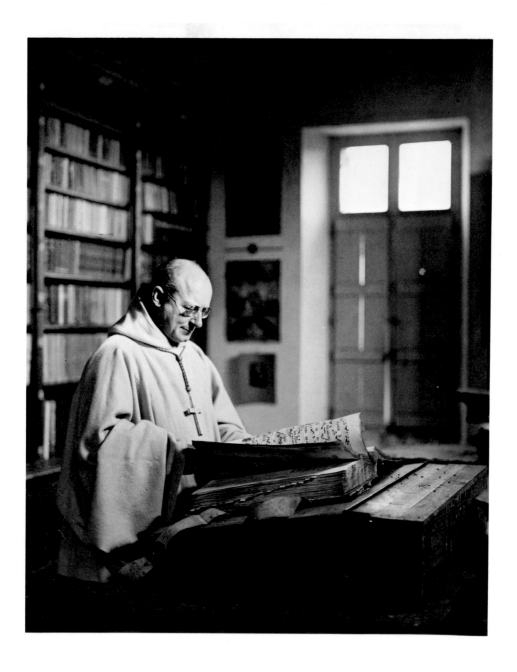

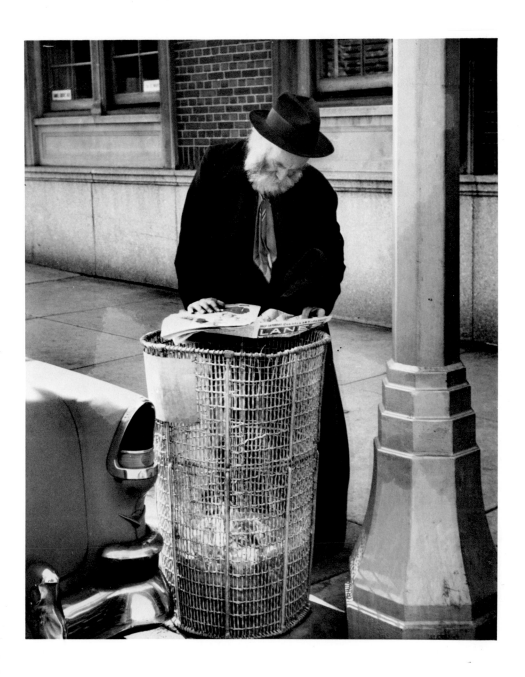

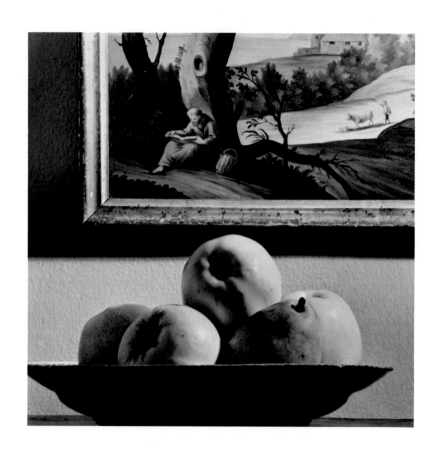

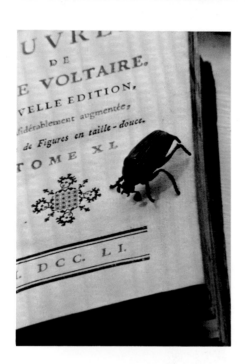

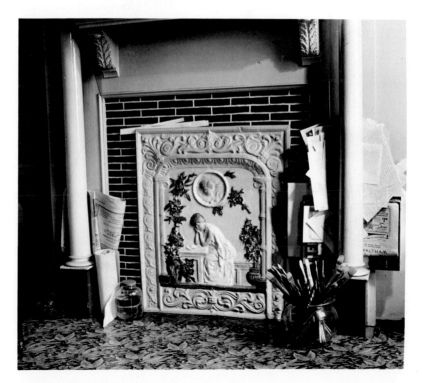

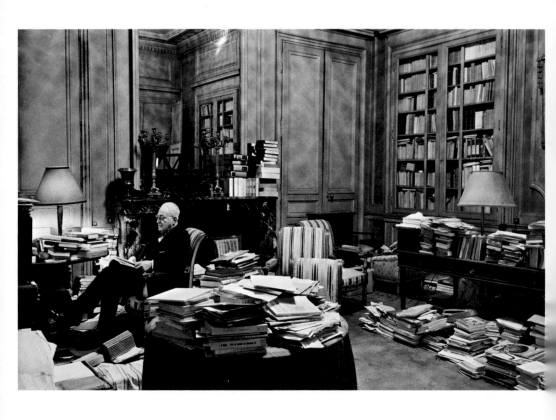

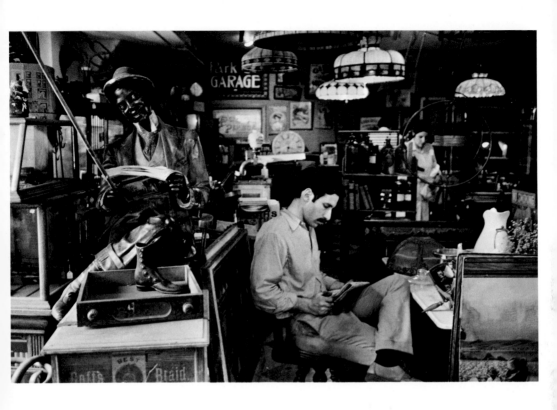

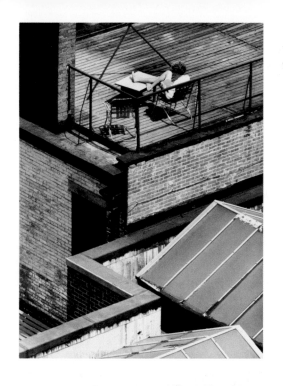

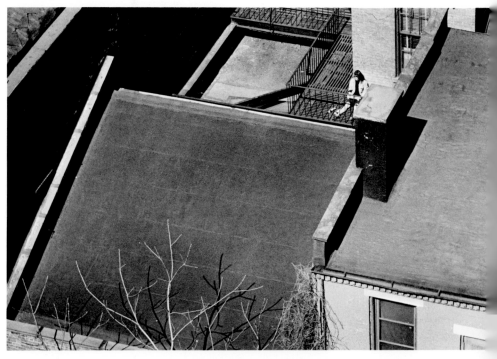

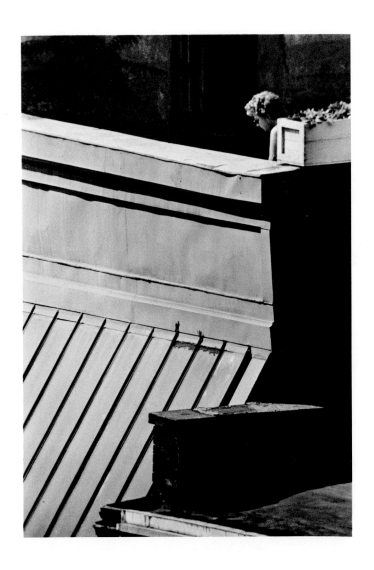

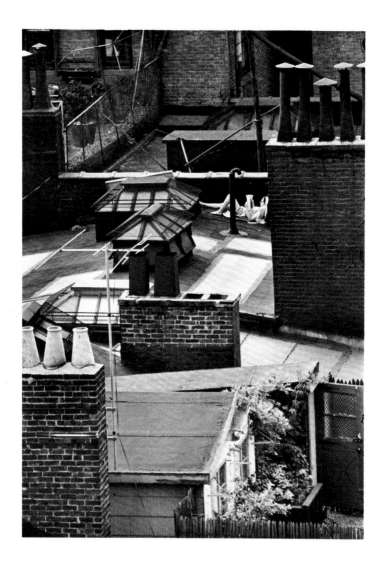

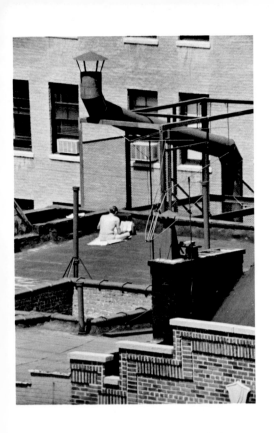

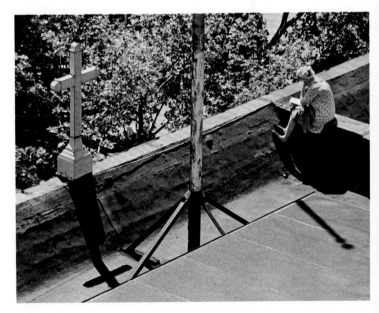

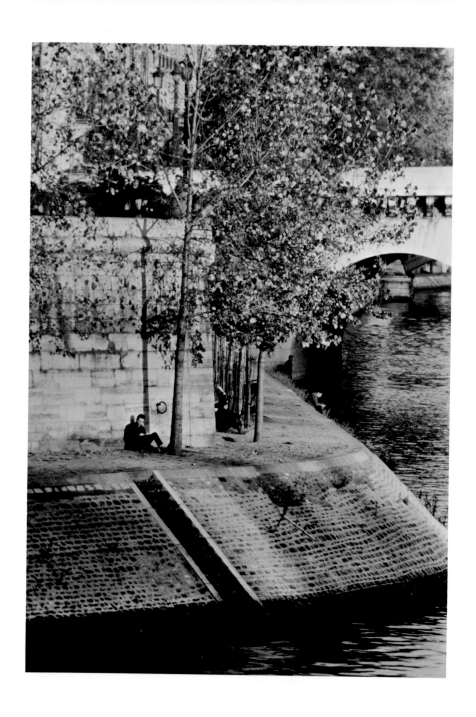

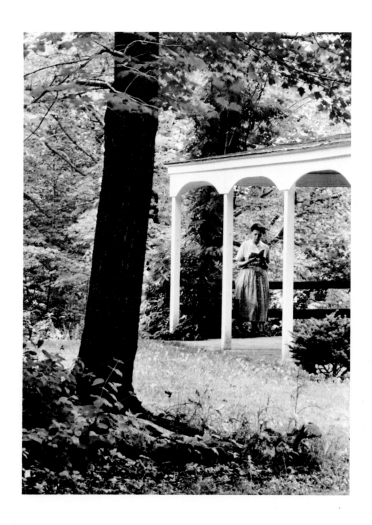

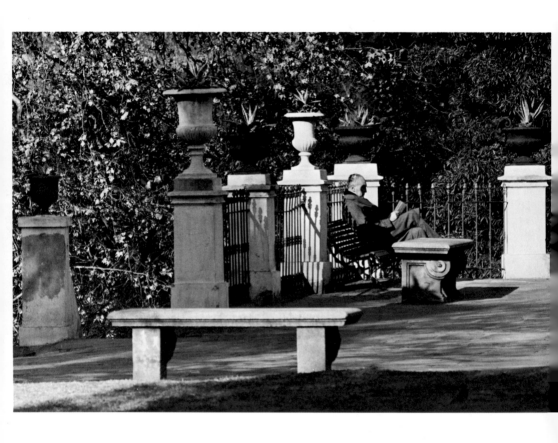

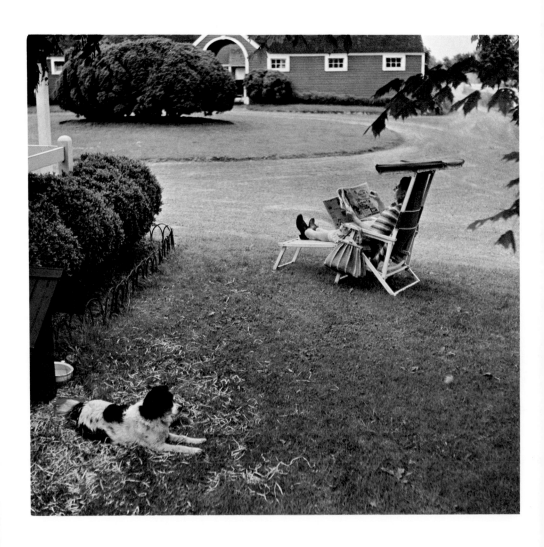

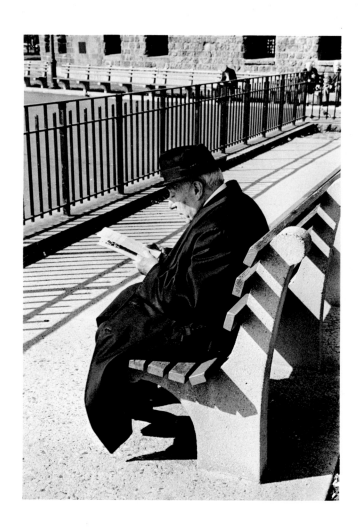

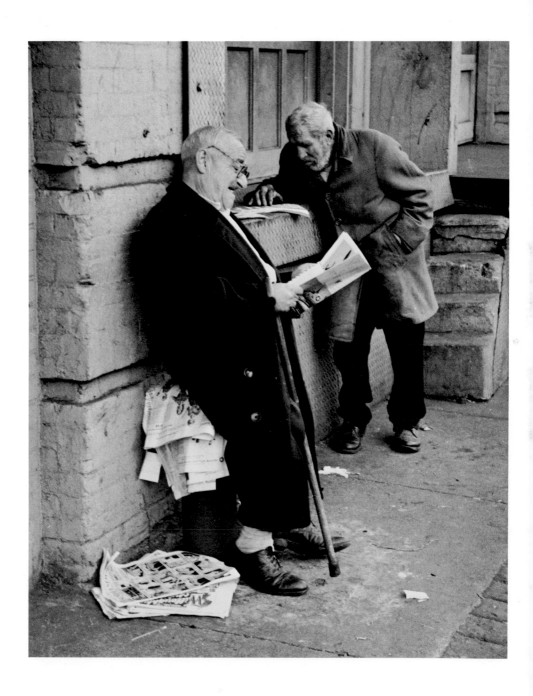

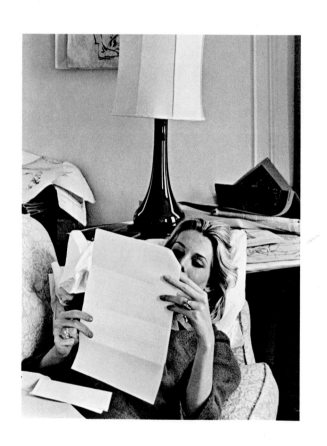

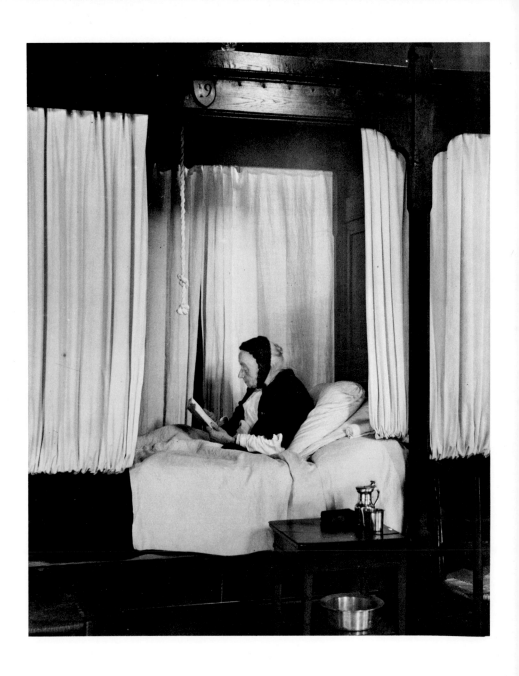

THE PHOTOGRAPHS